PADDLE AGAINST THE FLOW

LESSONS ON LIFE FROM DOERS,
CREATORS, AND CULTURAL REBELS

PADDLE AGAINST THE FLOW

huck

FOREWORD BY DOUGLAS COUPLAND

CHRONICLE BOOKS
SAN FRANCISCO

huck TCⴻL

Page 146 constitutes a continuation of the copyright page.

Library of Congress Cataloging-in-Publication Data available.

ISBN: 978-1-4521-3806-0

Manufactured in China

Designed by TCOLondon

10 9 8 7 6 5 4 3 2 1

Chronicle Books LLC
680 Second Street
San Francisco, California 94107
www.chroniclebooks.com

DEDICATION

This book is dedicated to the millions out there who have thrown out the rulebook, defied authority, and challenged "the way things are" to dream and try to make something different. The Huck Finns, Mos Defs, Spike Jonzes, Thoreaus, Zapatas, and Snowdens of the world. Everyone, really, who looked at the structure — restrictive, oppressive, and full of shit — and thought, "Fuck this," and instead chose to make it happen for themselves, refusing to be civilized while carving their own path to expression — and, ultimately, to freedom.

Have you ever paddled against the flow?
If so, this book's for you.

— *Vince Medeiros*
Founder, *Huck*

CONTENTS

FORE WORD

ON ADVICE

— By *Douglas Coupland* —

— 1 —

Cue image of Nathan, age 47, emerging from an alcoholic fog in a puddle of his own vomit mixed with thirteen binders of uncollated tractor sales reports and a dozen dead Nespresso capsules.
How did I get here? He asks. How did this become my life?

What happened to Nathan is that he didn't take advice. The problem with advice is that nobody ever takes it. And then they learn lessons the hard way, experience great suffering, and look back on their lives and say, "Man, I should have taken that good advice back then." Yes, that is correct. You should have.

Young people are especially bad at taking advice. This is because they have a protective coating surrounding them called youthful cluelessness — or obliviousness or blankness — but the net result is that they don't take what is often staggeringly good advice. Instead they wing it and go out in the world, have one disastrous experience after another, and suddenly they're forty-five and it's all over.

One of the things all young people learn as they become older people is that advice is actually a very good thing. Advice is probably actually the very best thing of all, because advice saves you time. If you ask anyone over fifty, which is more important, time or money, they will *always* tell you, time. You can always make more money, but you can't get back time that's been lost. It's gone.

———————— 2 ————————

Cue image of Jennifer, 49, staring at a frozen dinner entrée rotating within a microwave in her suite in a short-term executive lodging complex beside Interstate 90, awaiting a call back from Sheila in accounting to tell her if she can claim a parking ticket in her expense report. (Answer: No.)

The point is that there's no point in giving advice. Advice is only ever taken long after the point it was needed, acknowledged alone in a dark room at three in the morning at the age of forty-seven with a finger of Jack Daniels remaining in the bottle. So then — what do you offer people instead of advice? The answer is you try to inspire. Inspiring people is far easier than trying to give earnest advice, especially to people in the post-pubescent phase of neural wiring which makes them especially susceptible to powerful inspirational words. Behavioral psychologists generally agree this is the case because nature needs young men and women with pliable minds who can be made to go off to battle and willing to place ideals ahead of their own lives. You never see thirtysomethings or fortysomethings going off to war. There's a reason for that. They know that inspiration is a tool and a trap.

So what we have in this book is a great big pile of advice and inspiration that function both as tools and as traps. But the thing is, this advice comes from artists, and the thing about artists is that from an early age they knew they were different, and they knew they were never going to make it in the real world, and they knew they had to somehow create their own reality. This is a very hard thing to do. The numbers are terrifying. So if you're going to be inspired by anyone, be inspired by people who have been, I'm guessing, exactly where you are now, wondering if they can ever fit into the world in a way that's meaningful and creative and sustainable over decades.

———————— **3** ————————

Cue an image of Kyle, 50, at his brother-in-law's fiftieth and there's a shot of Kyle painting something on a canvas when he was twenty-five. The brother in-law makes a fart noise and everyone laughs and there went Kyle's life.

My hair went white at an early age — it runs in our family, so I was expecting it. But the thing about your hair going white is that suddenly people expect you to be wise, and out of nowhere, a few years back, I started getting invited to address graduating students as to how they might live their lives. What do I know? But I figured it out.

The one thing I know to be true in the world is that you, if you're creative, have to know what it is you enjoy doing. Most people don't know this. It's amazing how many people go to the grave without knowing what they like doing. I suppose this is how nature ensures there will always be people to man the counter at the local DMV. But the point is that if you know you like making shoes or candles or snowboards, no matter how much the world changes, you'll always be interested. Contrarily, if you launch a career doing something you don't really like, then even if you're successful, you won't feel successful, and you'll be contemptuous of your success.

Advice and inspiration: loaded ideas. But listen to what the people in this book have to say. They've been in your shoes and they're not here to waste your time. They're here to save your time, and that is, in practical terms, the greatest gift one human being can give another.

— *Doug*

INTRODUCTION

GENERATION DIY

"YOU KNOW THAT JOB YOU CAN'T GET? YOU DIDN'T WANT IT ANYWAY."

A light went on when I first heard this comment. Followed by the comforting thud of things falling into place.

We'd spent the best part of a decade acting on instinct, finding stories we wanted to hear about, talking to people we admired, making a magazine we could believe in and would want to read. At some point over the years we sat up to find ourselves surrounded by like-minds — people who made the effort to seek out new sources of inspiration, curious enough to question the familiarity that surrounded them, bold enough to build something that challenged what they knew.

A community had sprung up all around us, connected across cultures by a reassuring wink. It didn't have a defined face or name — there were photographers, artists, writers and filmmakers; skaters, punks, hip hop heads and activists; people who had day jobs but spent their lunchtimes plotting something bigger, and wide-eyed independents who'd already made the leap. Most of them cross-stepped effortlessly between all of the above, making things fueled by their passion, fueling their passion with the things they chose to make. They were doers. People who made something happen because they had the urge to make something happen.

But it wasn't until I heard this comment, from a friend of the magazine who came to us with the clarity of fresh eyes, that I realized why the 18-year-old skate rat who just started his own record label out of his bedroom will forever be bound to the 30-year-old artisan who taught herself how to use power tools so that she could make something beautiful without relying on anyone else; why the surfer photojournalist out on the frontlines is tied to the bike-obsessed activist typing away at home. Frustration. If there's one thing that connects us, it's the frustrated urgency of youth. Pushing beyond the finality of that deadening disbelief that the things we were promised will ever materialize, then waking up to the revelation that we never wanted them all along.

That job in the mega-corp that you applied for and didn't get? That door you keep knocking on that refuses to budge? That article you read, that song you heard, that ridiculous film that made you feel below par? The fact that life blows your mind almost every day, yet the stories clogging up your social feed leave you feeling numb? The utter loneliness of not recognizing yourself in the culture you consume.

These frustrations come at us all the time — faster and more frequently, it feels, than ever before. In an era that's turned opportunity into a dwindling resource, our failures are blasted back at us — on hand-held devices in hi-def mode — across an infinite web of channels every second of the day. Most people let it wash over them like a quiet tidal wave. They accept frustration as the fabric of life, the stuff you need to tolerate in order to get by. But some people grab hold of that first angry little spark, blow it up instinctively into a raging fireball and, in that midnight moment when wild dreams feel real, they chuck it at the world just to see what catches light then stand back and say, "See that fire over there? That one's mine."

It's these people that inspire us to keep making *Huck*. It's their boundless curiosity that keeps us digging around the underground for untold stories capable of blowing minds. It's their lifelong desire to keep pushing and learning that forces us to question the perceived way of things. It's their ability to discern between words of wisdom and bouncy soundbytes that leads us away from the bright lights of transient stars and towards the people who work tirelessly at their craft, from filmmakers like Spike Jonze to writers like Douglas Coupland, from artists like Swoon to skateboarders like Mark Gonzales — fireball creatives who had the balls to turn the whole world to ash so that a new generation could plant something for themselves.

This book is dedicated to our readers. And all those angry little sparks that keep us paddling against the flow.

— *Andrea Kurland*
Editor, *Huck*

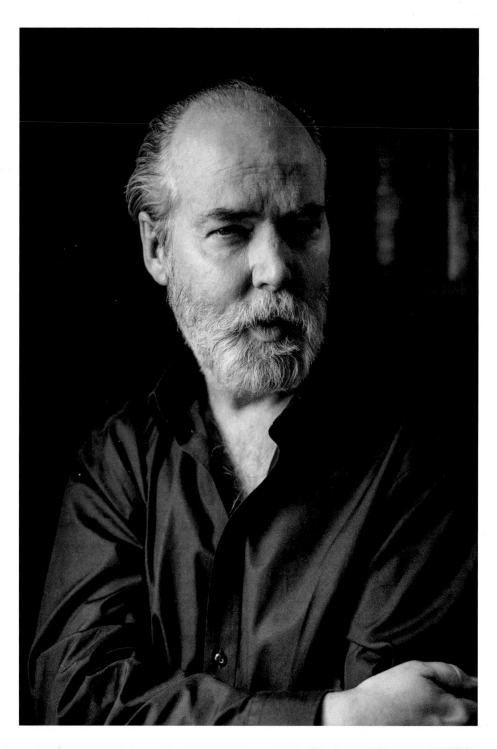

— DOUGLAS —
COUPLAND

WRITER

If you're being
bombarded with
information, the act of
looking for patterns —
not necessarily finding
them — is what's going
to give you psychic
refuge, a sense
of sanctuary.

— KELLY —

SLATER

SURFER

Any sport can be
compared to games of
chess. One move has
to balance another
move. When things get
imbalanced, that's when
somebody controls
the game.

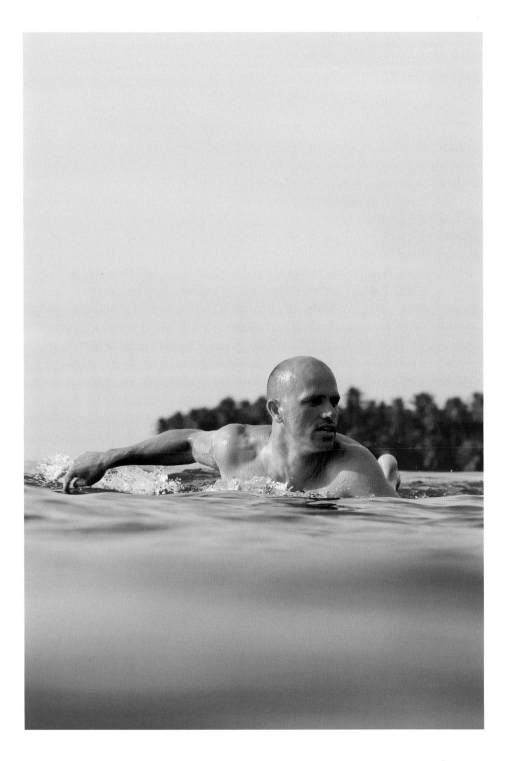

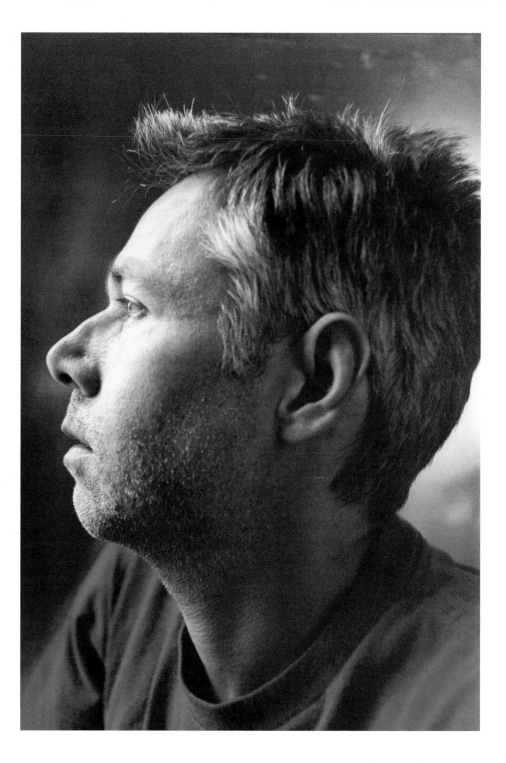

MCA

—— *MUSICIAN* ——

One day you're not able to do something and then you are able to do it the next day, you're challenging yourself. There's definitely something addictive about the process.

— CHERYL —

DUNN

— PHOTOGRAPHER —

It's good to make your
mistakes when you're young
and not afraid. But you should
never be afraid to make mistakes.
Life moves at the speed of light.
People forget the mistakes.
Just keep making.

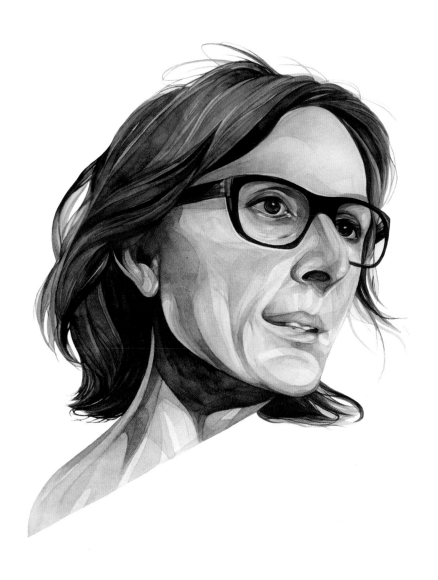

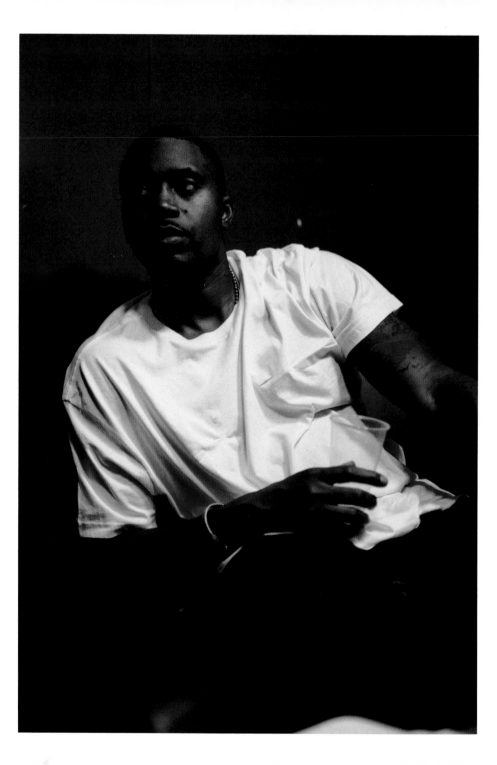

NAS

— MUSICIAN —

Music changed my life. It gave me a new vocabulary to negotiate my feelings. It gave me a new identity — a new possibility.

— MIKE —
MILLS

— *FILMMAKER* —

There's a long streak of melancholia in my world. Often when I'm sad, I make things to get out of the sadness. Everything is more emotionally vivid when you're sad.

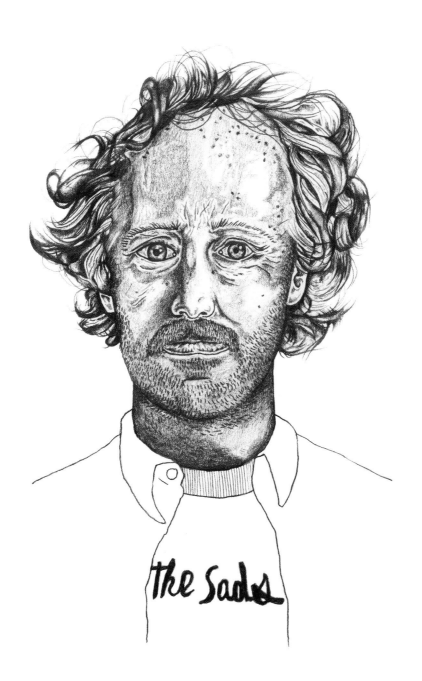

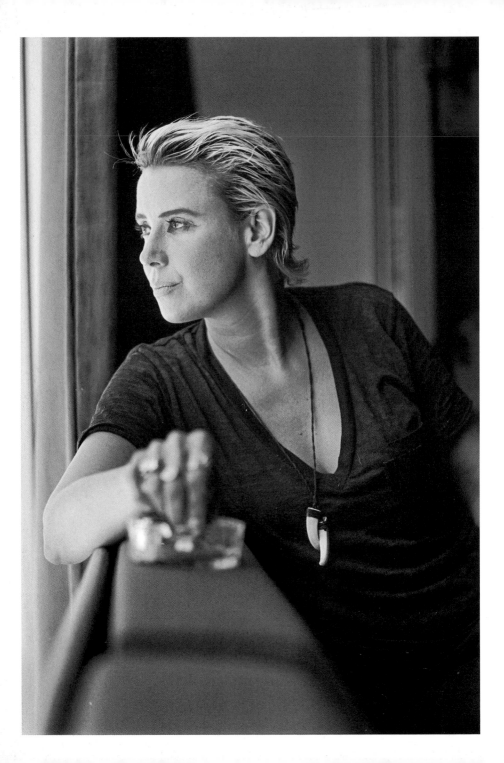

— CAT —

POWER

—— *MUSICIAN* ——

Art brings you
closer to whatever your
present is, your own
breathing being.

— SHAUN — **WHITE**

—SNOWBOARDER—

Treat every contest like it's your first, like you want it so bad, and then give it your all. I'm that way with everything. You should see me play Monopoly, it gets nasty.

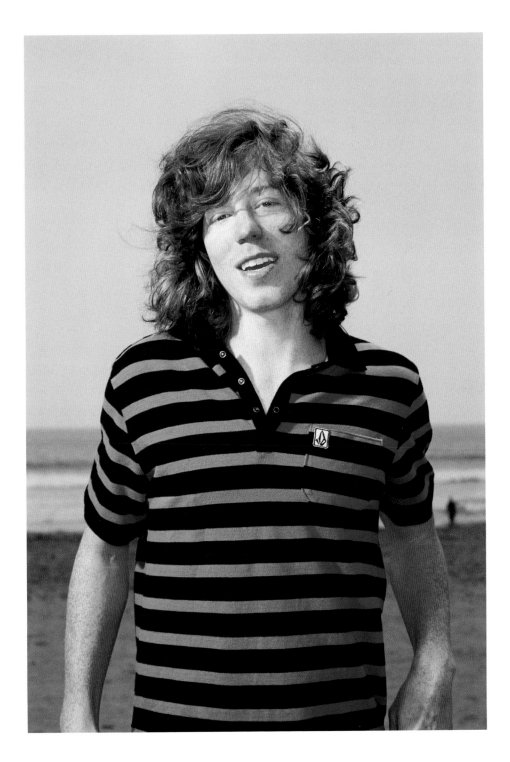

— LANCE —

BANGS

—— FILMMAKER ——

When I was younger I began documenting what I was going through. "This is the twenty-four hour laundromat I'm in. This is what the lights look like and here I am talking into this tape recorder." I was just preserving myself. It felt like I was going to disappear and not be around anymore. So it was more like writing a journal than traditional filmmaking.

— SHAUN —
TOMSON

SURFER

Why do people make
bad choices? A lot of it is
related to a lack of hope;
it's related to despair.
Find out what you love
and pursue that dream so
that your life is filled
with hope.

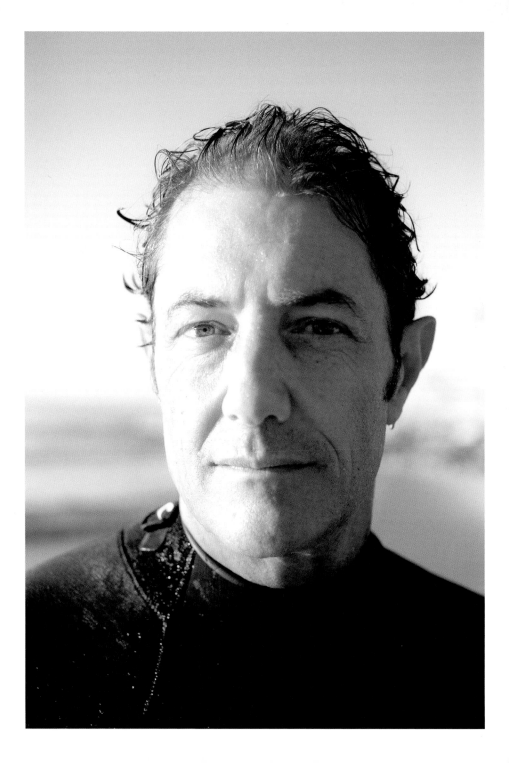

— TONY —

ALVA

— SKATEBOARDER —

There's no limit to what
you can do on a skateboard.
It's freedom. It's independence.
It's acceleration. And it's that
thing that burns inside you. It's
like the cleanest, purest form of
high that you can get.

— BOB —

BURNQUIST

SKATEBOARDER

Everything takes time —
the only way to get things
done is to do it. It can be
overwhelming, but the
key is to set goals and
take it one day at
a time.

— RIVERS —
CUOMO

—— *MUSICIAN* ——

It's good to work in an experimental way where you're trying things out and you're not attached to the result.

— SPIKE —

JONZE

—— FILMMAKER ——

Don't differentiate between "This is a job" and "This is what I'm doing for fun." It's all simultaneous.

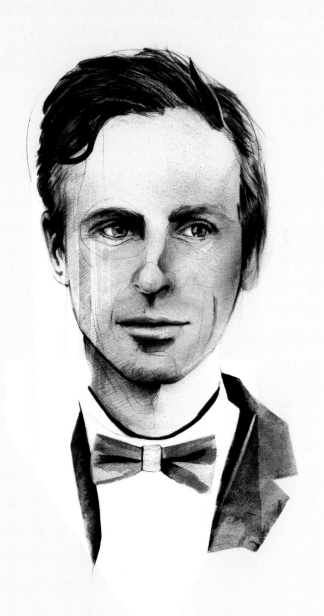

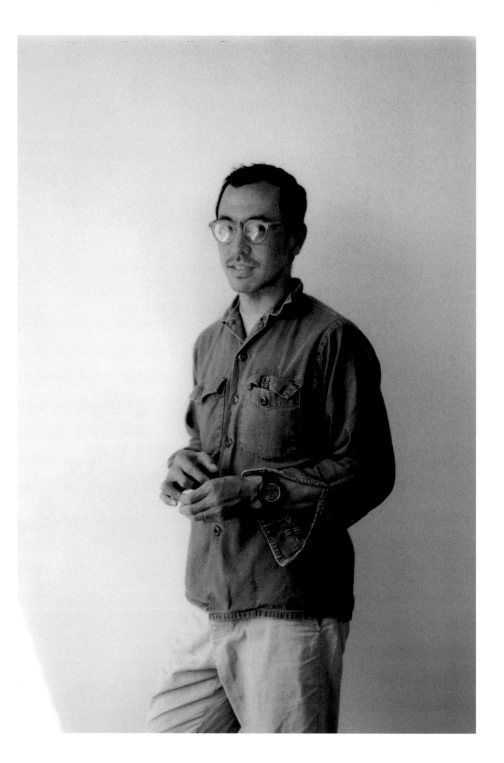

— GEOFF —
McFETRIDGE

GRAPHIC DESIGNER

Drawing is the opposite
of work, it's mindlessness.
Stop learning, stop struggling,
stop testing yourself. Do what
you're good at. When I really
learned this it was a big growing-
up moment — I finally felt
commitment to what
I was doing.

— ALEX —
KNOST

SURFER

Great results can
come out of having limited
resources. When you have fewer
options, things develop out of
necessity. And in a weird way
the necessity creates
originality.

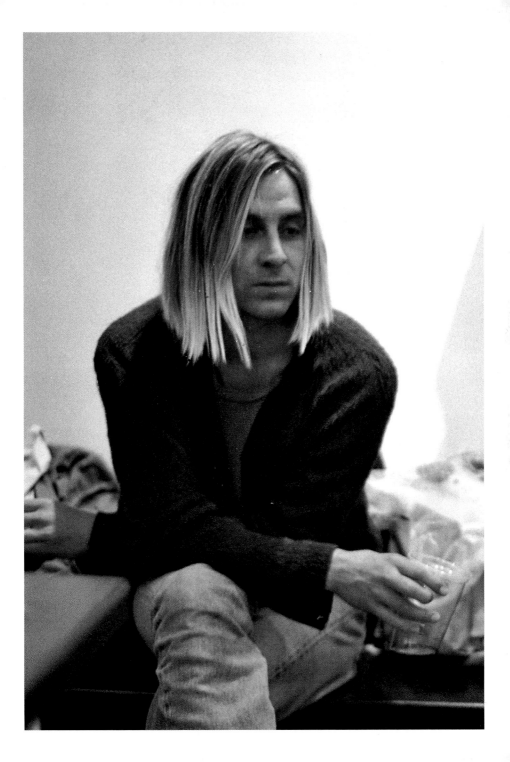

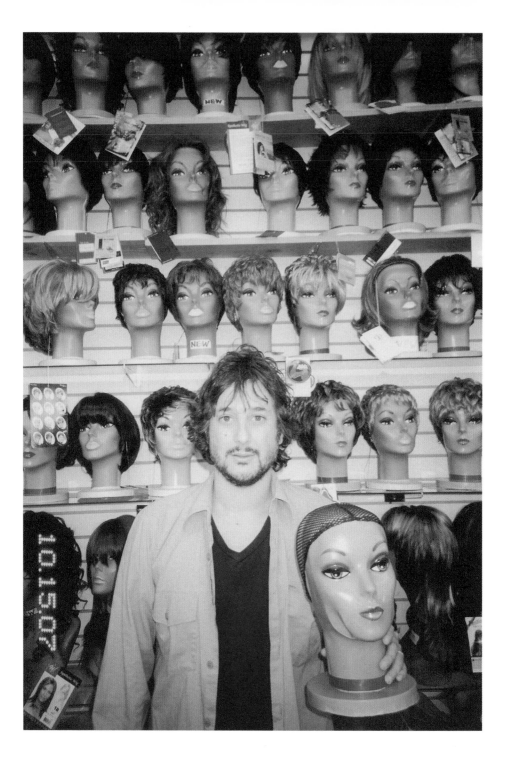

—HARMONY—
KORINE

FILMMAKER

Make things because you want
to make things. Whether it's a
movie or a one-line sentence or a
song that you sing to yourself in the
shower, you just do it because it's
something you want to do. All that
stuff about deals and money, that's
bullshit. There's just something
wonderful in the act of creating.

— ROBERT —
RODRIGUEZ

FILMMAKER

If you want to make films, don't say
you want to make films. Just say
you're a filmmaker. People are very
true to their identity. If your identity is
someone who someday would like to
make a film then you're going to remain
someone who someday would like to
make a film. If your identity is being
a filmmaker, you're going to do what
filmmakers do, which is make stuff.

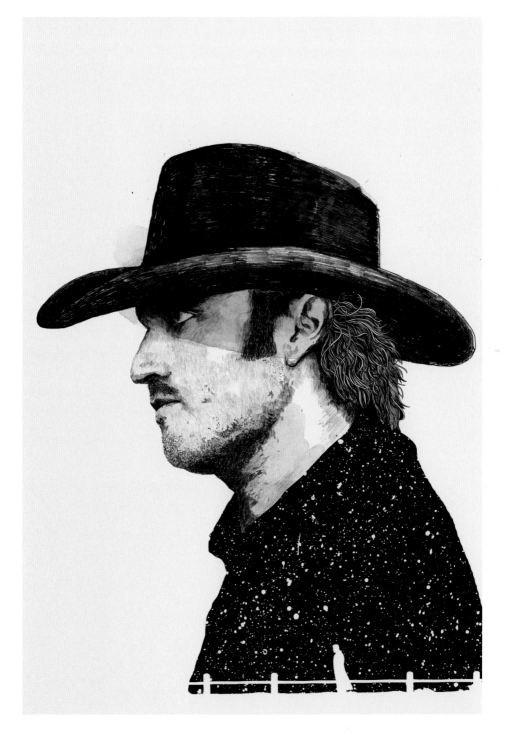

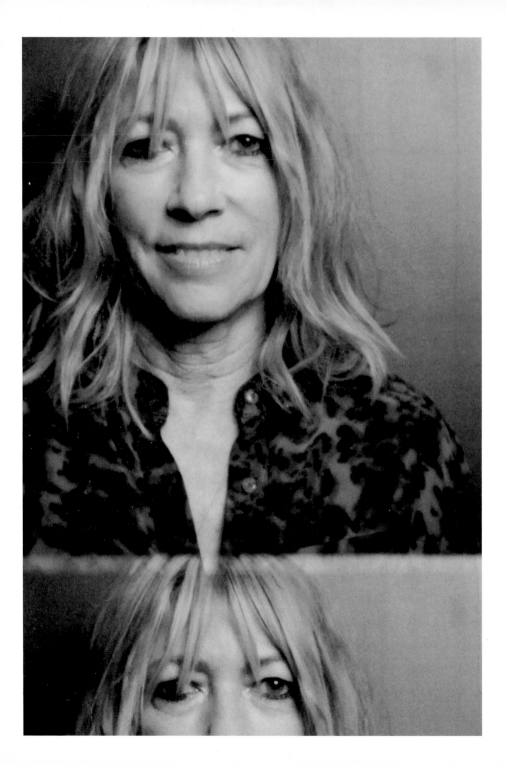

— KIM —

GORDON

MUSICIAN

If everything's
going well, you're on
this ride, and you're
taking the audience with
you, somewhere, but you
don't know where
you're going.

— RALPH —
STEADMAN

ARTIST

The thing about drawing is not to pencil in first and try to go over it. Start directly in ink, or something that makes a mark you cannot rub out. People say, "Don't you make mistakes?" Of course you make mistakes! But there's no such thing as a mistake really. It's just an opportunity to do something else.

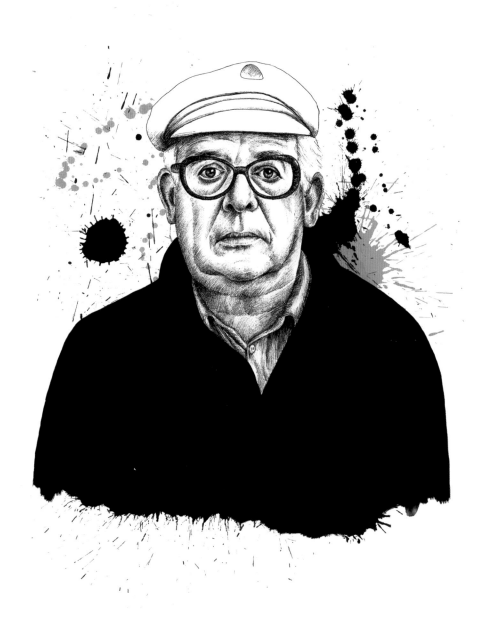

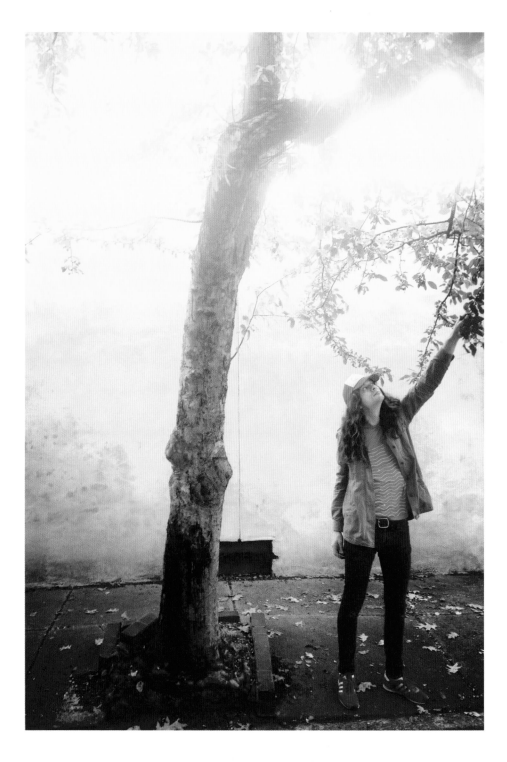

— KURT —
VILE

— MUSICIAN —

When I pick up a guitar, it's not like I'm thinking, "I want to find this dreamy chord." It's just there. I chant and the imagery kind of floats through my head. It depends on the mood, too. My mind could be moving so quickly that the lyrics just pop out. No matter what, be a receptor in the moment to your stream of consciousness and subconscious.

BECK

— *MUSICIAN* —

We're limited by language, but as a lyricist, you try to use it in a way that isn't clichéd and tired in order to say something new.

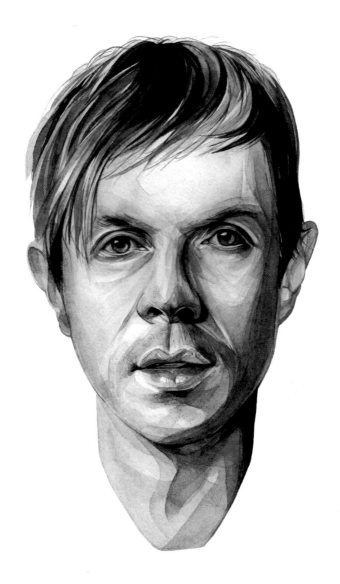

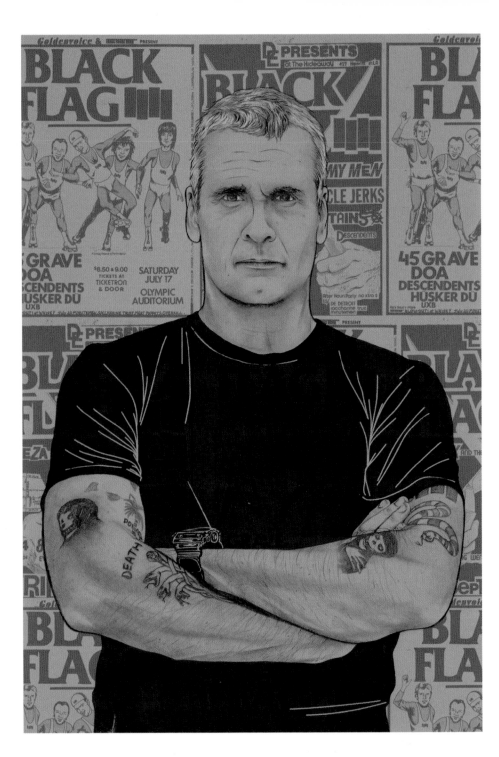

— HENRY —
ROLLINS

——— MUSICIAN ———

Discipline is a great way to get things done. It goes like a hot knife through butter in the entertainment industry when everyone else is waking up at two in the afternoon, and you can get up at 6 A.M. and get all your work done. Performing solo, owning my own publishing company; it was the discipline and the focus and the tenacity that got me through. Not my talent — I don't have any.

— MARK —

GONZALES

———— SKATEBOARDER ————

Sometimes when I'm drawing I morph back into a little kid.

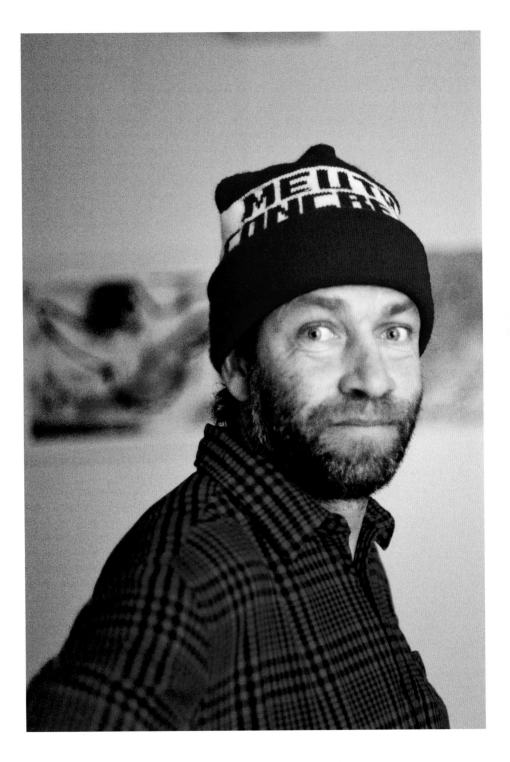

—MIRANDA—
JULY

—— FILMMAKER ——

No sooner do I feel
something new, good or
bad, than I'm immediately
trying to translate it into
my work.

— JULIAN —

CASABLANCAS

MUSICIAN

Develop a desire to get everything right. Maybe that's obsessive — it's time-consuming for sure. But it really pays off in the end.

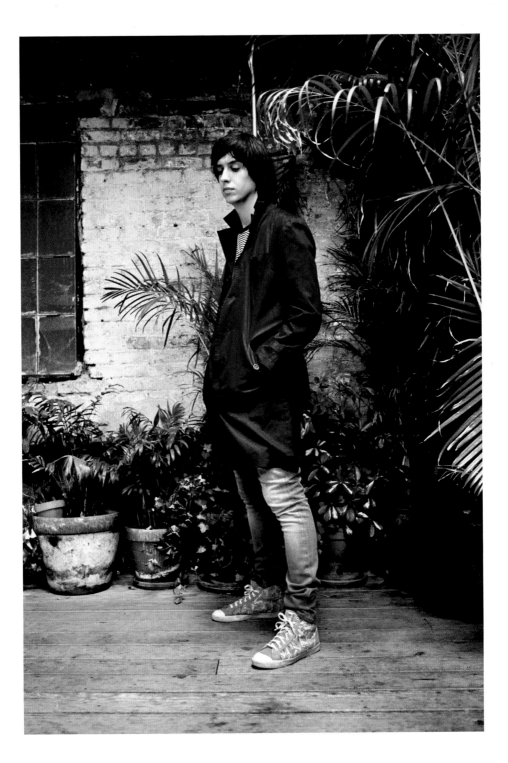

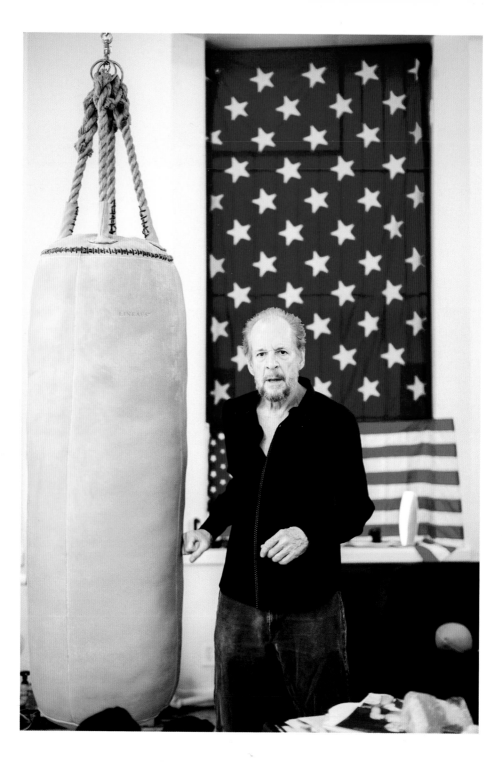

— LARRY —
CLARK

FILMMAKER

I always think of my
work as a comeback —
like I'm an older boxer
training for a fight.
Just one more fight.

— WERNER —
HERZOG

FILMMAKER

Martin Luther King was asked,
"If the world came to an end
tomorrow, what would you do
today?" and he said, "I would
plant an apple tree." Well,
on the last day of the world,
I would shoot a movie.

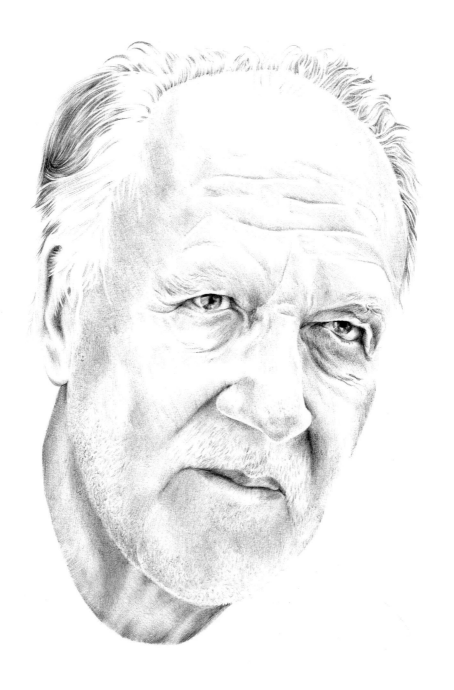

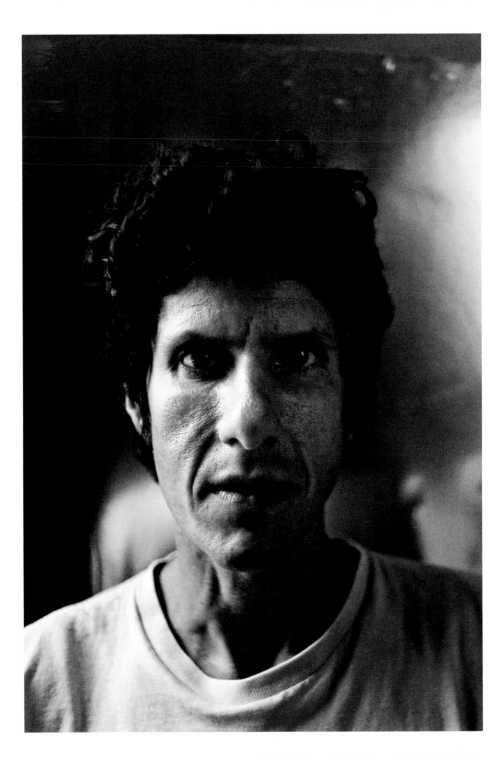

— MIKE —

D

— *MUSICIAN* —

We haven't got to where
we are without the talent to
back it up. You gotta have luck
in terms of the door opening.
But to keep the door open,
you have to come with
something.

— DAVID —
BYRNE

MUSICIAN

Most of what I do is not meant to be obscure or difficult. It's meant to be accessible. That doesn't mean that the music I make, for example, is meant to be the lowest common denominator of popular. But it doesn't go out of its way to push you away — it kind of welcomes you. There's nothing about it that says, "We're better than you."

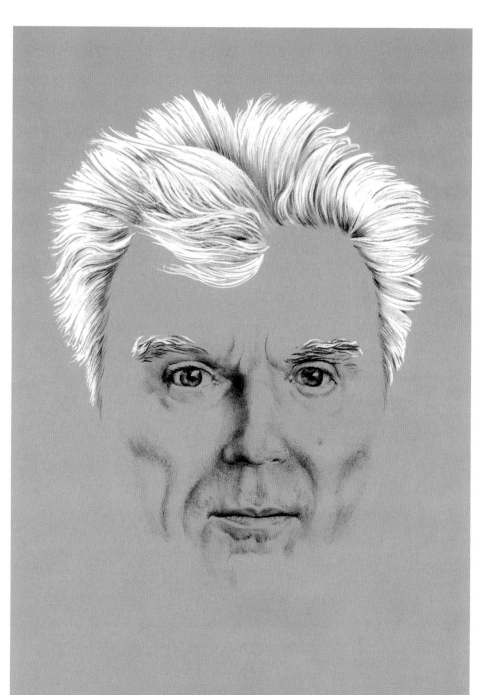

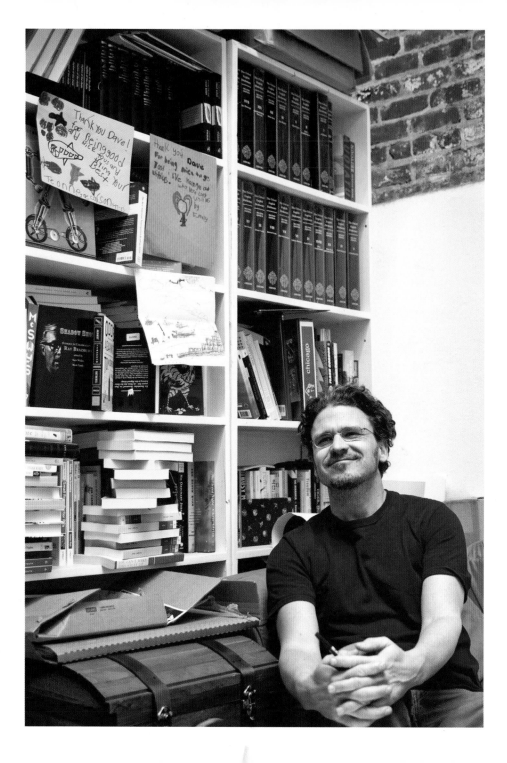

— DAVE —
EGGERS

—— WRITER ——

When you're in your
twenties in a new city where no
one's from here, we're all sort of
orphans. The only people that
you can count on are a bunch of
people that you work with and
that you know. You're only
as good as the reliability
of that latticework.

— THOMAS —

CAMPBELL

ARTIST

Every single
person is a different
chemistry experiment.
Anything can be right
for anyone.

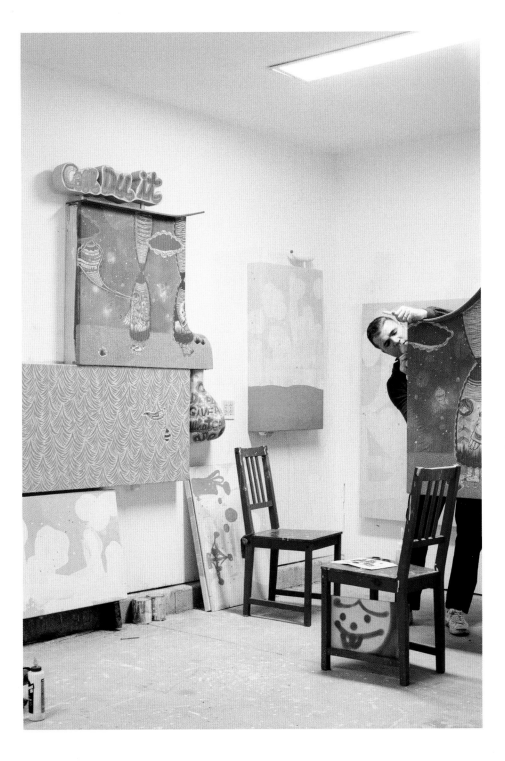

— ED —

TEMPLETON

ARTIST

You don't have to go places
to find inspiration. It's all right in
your backyard. Photography has
trained my brain to see where I
live in the same way as I
see other places.

—SHEPARD—

FAIREY

——— ARTIST ———

Some people will really
dig what you create, while
other people might not like it.
But you're contributing to the
dialogue. There's something
that's so basic in doing
something to relate to your
fellow human beings.

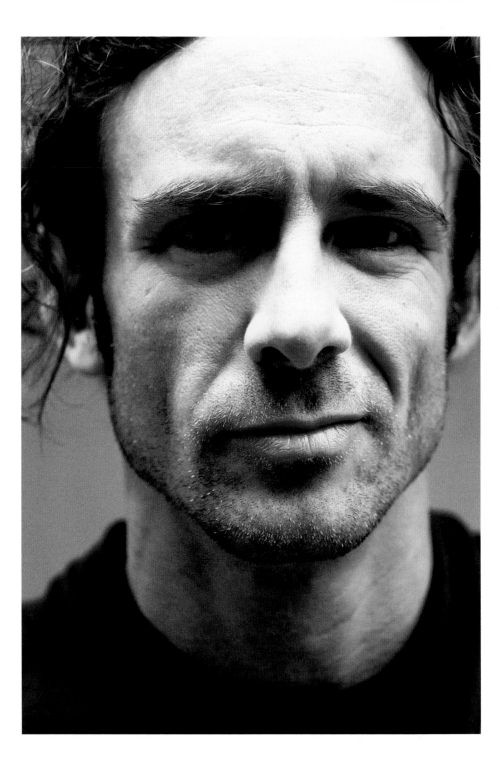

— CHUCK —

PALAHNIUK

WRITER

I'm always looking for "fringe" cultures, or communities, to see how people react to them, how they resonate for people. I'm looking for something that might be an improvement on what we have now.

— PHARRELL —

WILLIAMS

—— *MUSICIAN* ——

Bounce ideas off
each other — keep pouring
things in like a melting pot.
When it sounds right,
it sounds right.

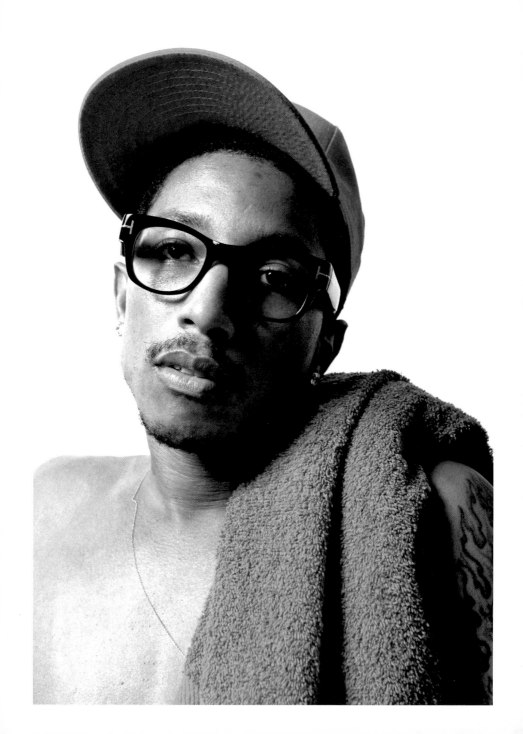

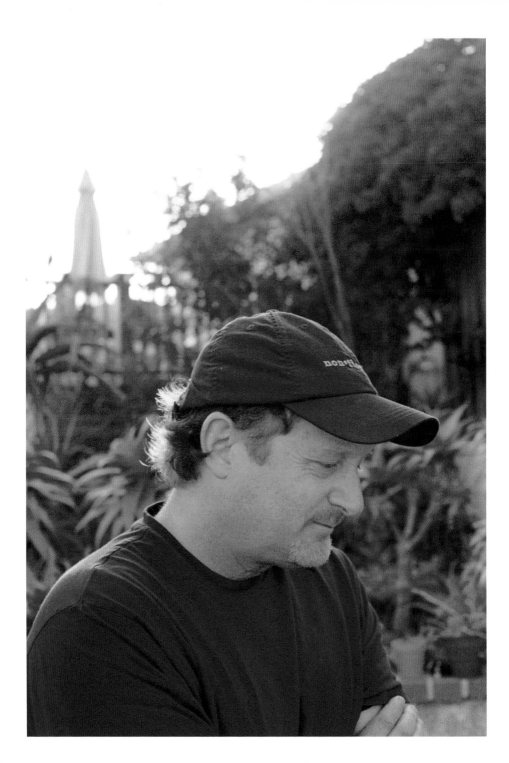

— STACY —

PERALTA

SKATEBOARDER

Skateboarding opens your mind. You can't skateboard well without having some sort of an open mind because the whole act of skateboarding is overcoming obstacles.

— DON —
LETTS

—— *MUSICIAN* ——

Punk made me realize
I didn't want to be just a fan.
We were like-minded outcasts
who reinvented ourselves
as writers, photographers,
fashion designers, artists,
and filmmakers.

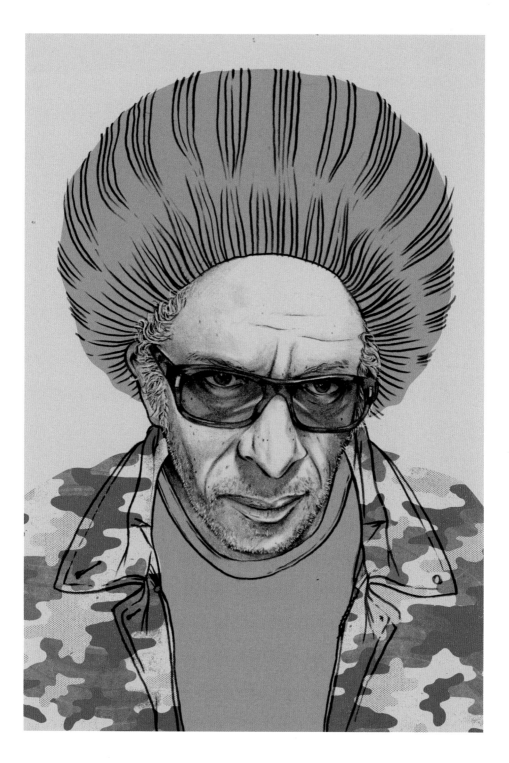

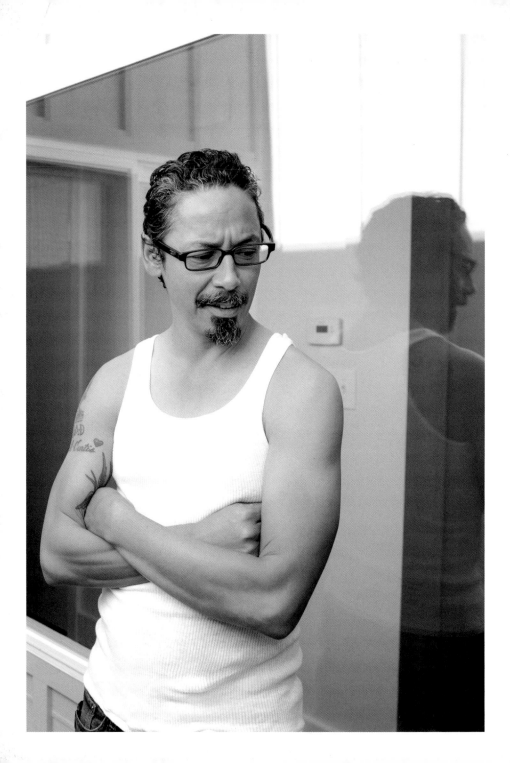

— TOMMY —
GUERRERO

SKATEBOARDER

I like playing music with other people because it's like having a conversation, instead of a constant masturbatory existence of loneliness. I get tired of myself.

— BEN —
HARPER

MUSICIAN

People are the only
animals on the planet
that are in denial that
they are an animal.

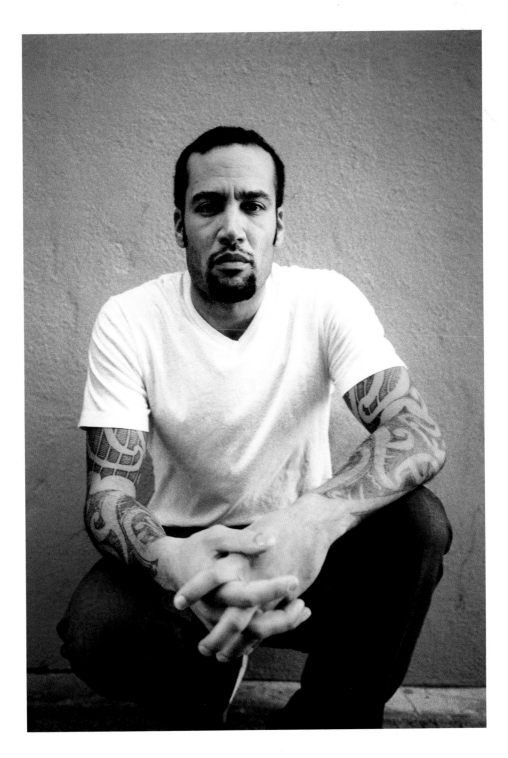

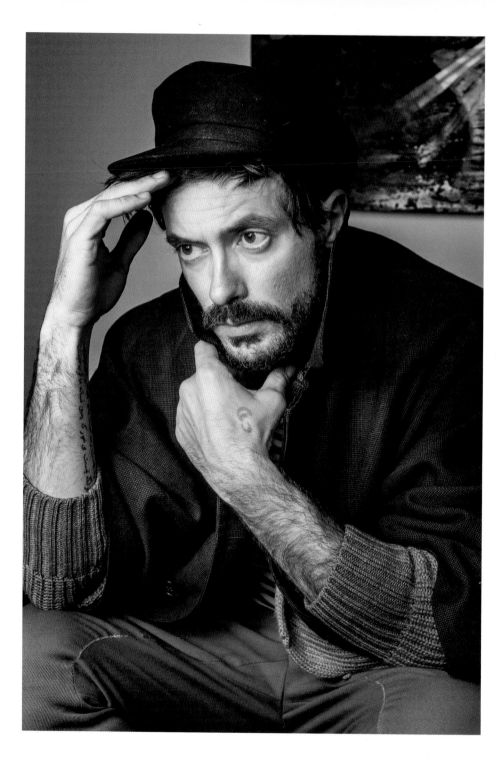

—VINCENT—
MOON

—— *FILMMAKER* ——

A lot of people think respect is stepping backwards, but I think respect is about stepping forwards — engaging as much as possible.

— BEN —

GIBBARD

—— MUSICIAN ——

I wanted to be the Jack Kerouac
to all my Neal Cassadys, I wanted
to be the person who wrote about
the experiences of my group
of friends, in a cinematic and
glorifying way that aggrandized
people who were probably
just normal people.

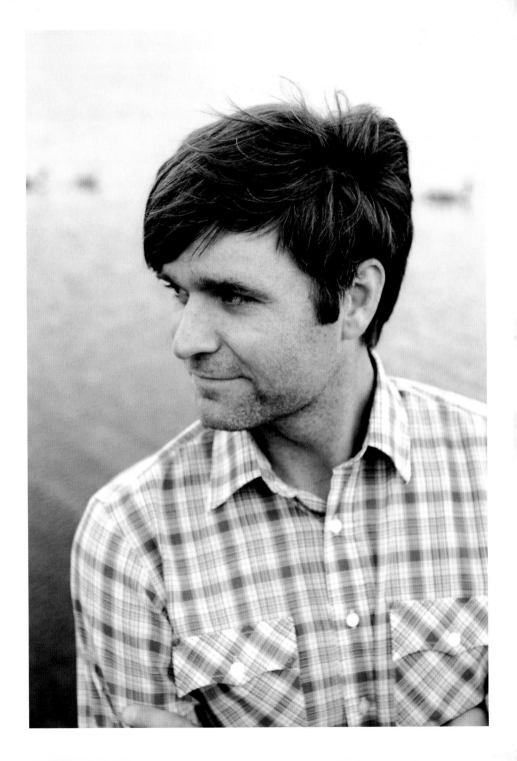

— ALEX —

GIBNEY

—— *FILMMAKER* ——

If you go in thinking that you're smarter than everyone else, you won't end up learning very much. If you go in thinking, "I'd sure like to understand this better," you end up doing precisely that.

BOOGIE

PHOTOGRAPHER

You can't be a fly on
the wall unless people
accept your presence.
That's the ultimate goal.
To disappear takes
trust and time.

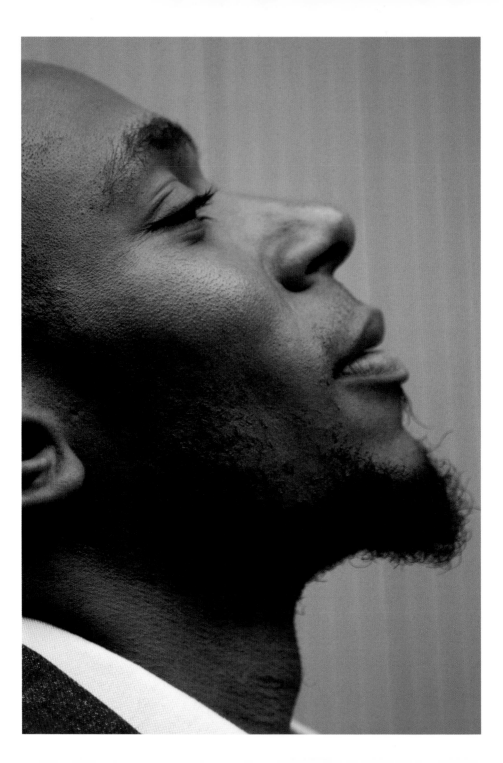

— MOS —

DEF

— *MUSICIAN* —

Comfortable people do not become revolutionaries.

—KALLE—
LASN
—— PUBLISHER ——

The Internet has given us a new model of activism which I think is the best model we've ever had. There's a lot of potential that we haven't even started to realize yet.

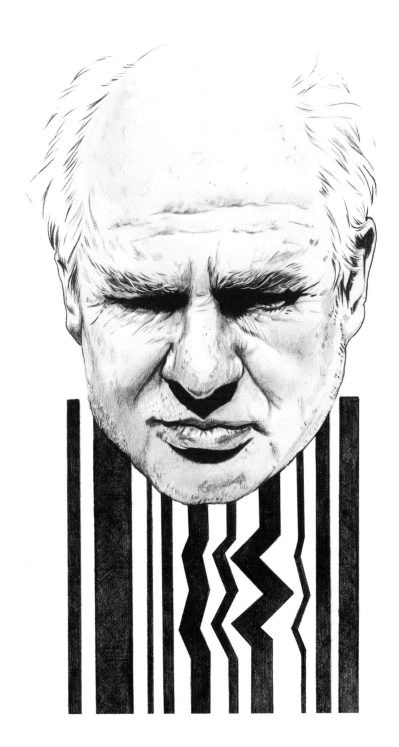

— C.R. —
STECYK III

ARTIST

The best thing about living
now is that media is completely
controlled by the individual. Any
person with a phone can make a movie,
edit it, download it, and link to it, and
several million people can see it in
twenty-four hours' time. It used to be
only the technologically elite who had
access, but now we're on an
equal playing field.

— CHIMAMANDA —
NGOZI ADICHIE

WRITER

It's important to point out where things are lacking, but it's even more important to try and offer a solution.

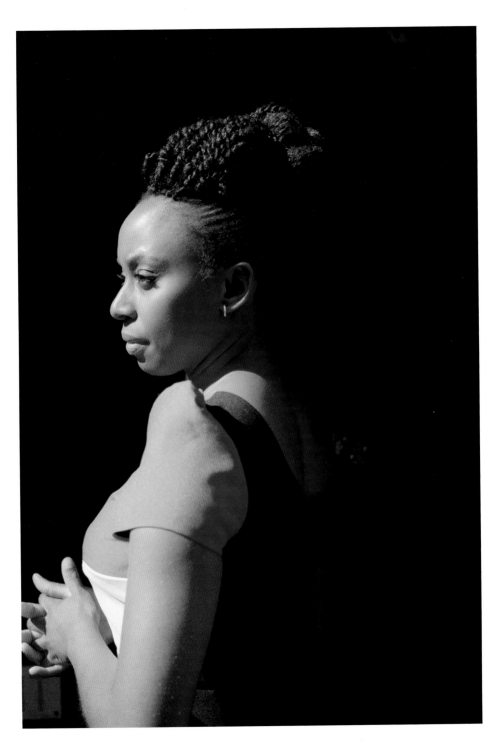

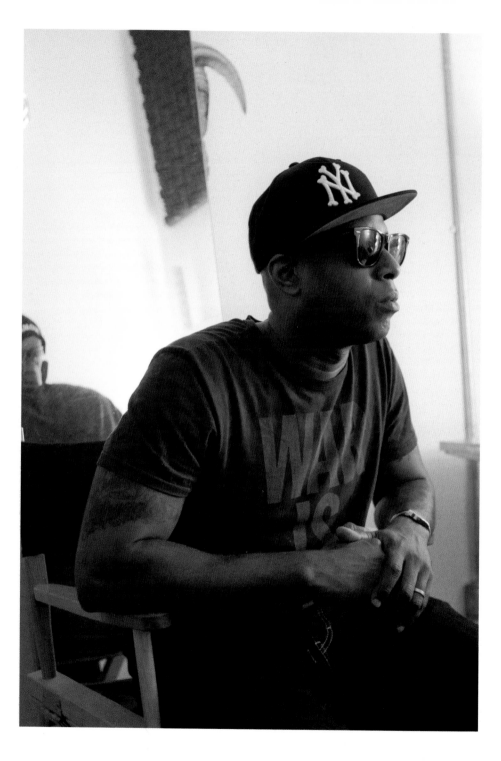

— TALIB —

KWELI

—— *MUSICIAN* ——

Artists have
one responsibility:
to be honest in
their craft.

SWOON

ARTIST

When you are trying to
do something and people tell
you, "No," it's not because
they're gonna stop you. They
just don't wanna be the one
who gave you permission.

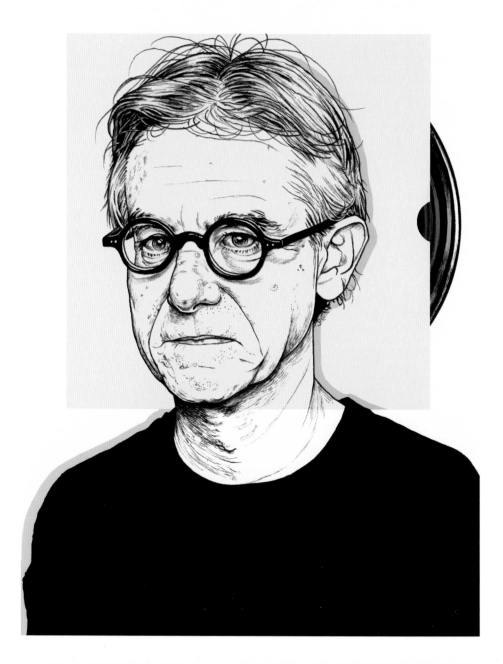

— GREIL —
MARCUS

WRITER

One of the interesting things about artists is that they know things that other people don't. Whether it's an emotional reaction, whether it's an intellectual insight. And the reason they're artists is because they want to tell other people what those things are. They're saying, "This is what the world looks like to me."

— PENNY —

RIMBAUD

———— *MUSICIAN* ————

Anyone can do whatever it is they want to do, but you need to actually get out and do it. Find a way of unconditional living.

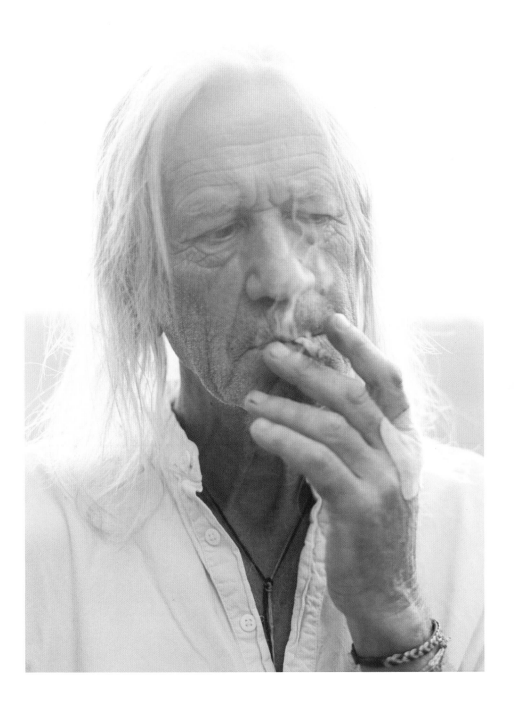

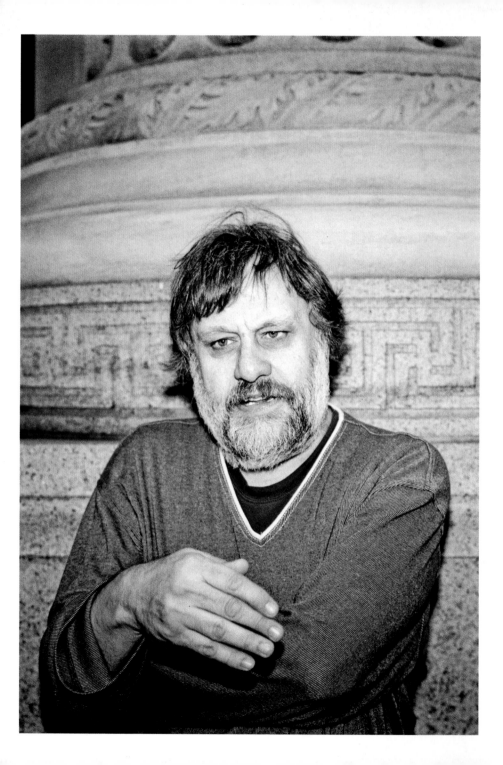

— SLAVOJ —

ŽIŽEK

—— PHILOSOPHER ——

You cannot change
people but you can
change the system so that
people are not pushed
into doing evil things.

— DAVE —

RASTOVICH

SURFER

The moments where I feel
life is overwhelming and
difficult are very brief. They
pass by like a shitty wave in the
surf. You just let that one go as
there are more waves to come.

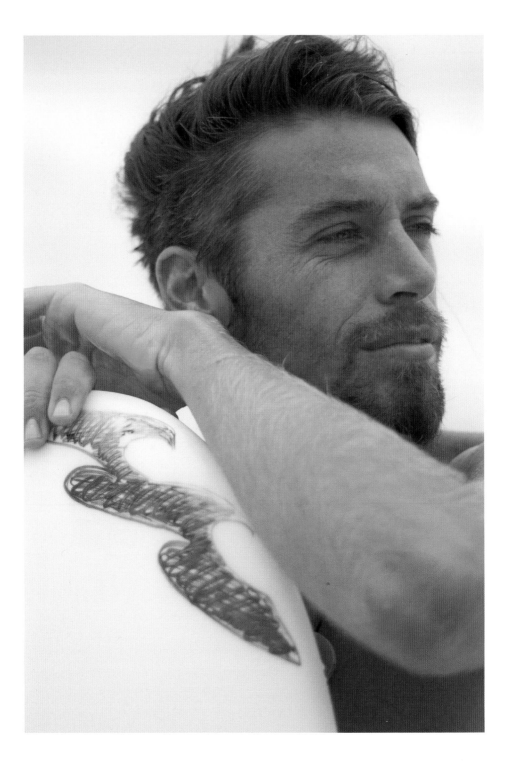

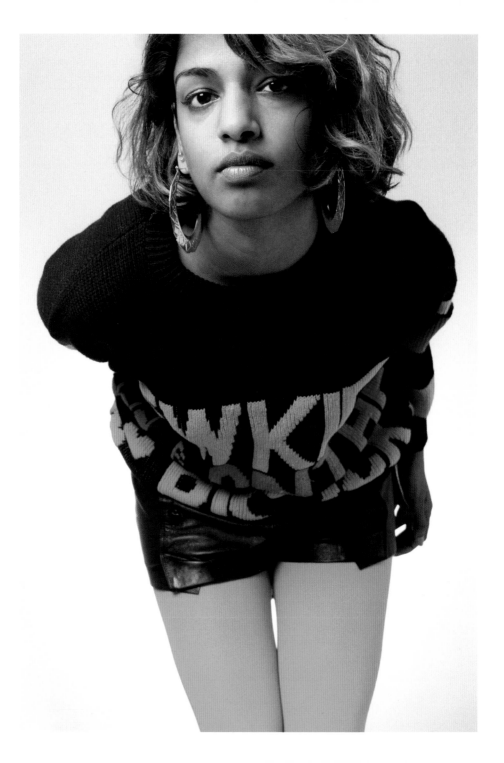

MIA

— *MUSICIAN* —

There are things
I'm gonna find on this
planet that no one has
ever heard before.

— EDDIE —
VEDDER

MUSICIAN

It's strange to be recognized
for doing environmental
work. It's like getting an award
for breathing — it's simply
something you have to
do to stay alive.

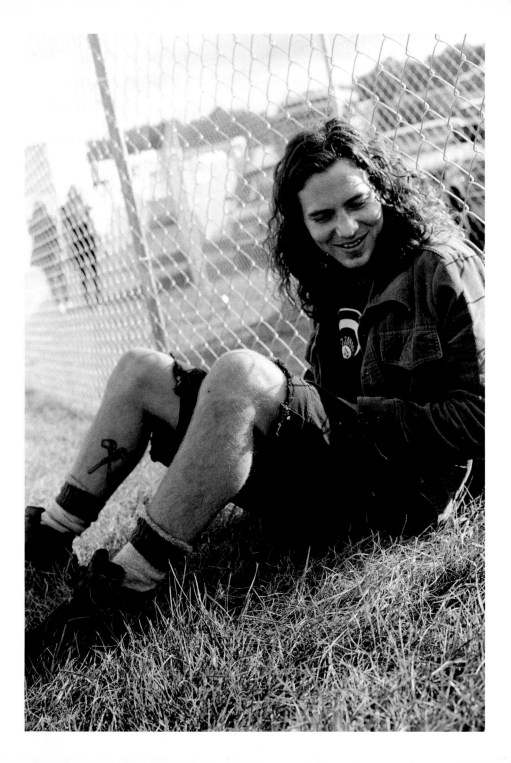

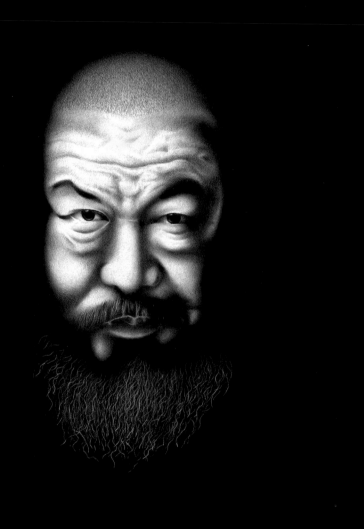

— AI —

WEIWEI

———— ARTIST ————

I don't think I'm a dissident artist. I see them as a dissident government.

— IAN —

MACKAYE

—— MUSICIAN ——

Violence is an effective form
of communication, but it's an
incredibly stupid one. And people
who are not interested move away
from it. It starts when people
back away from the stage and
eventually it drives them
right out of the room.

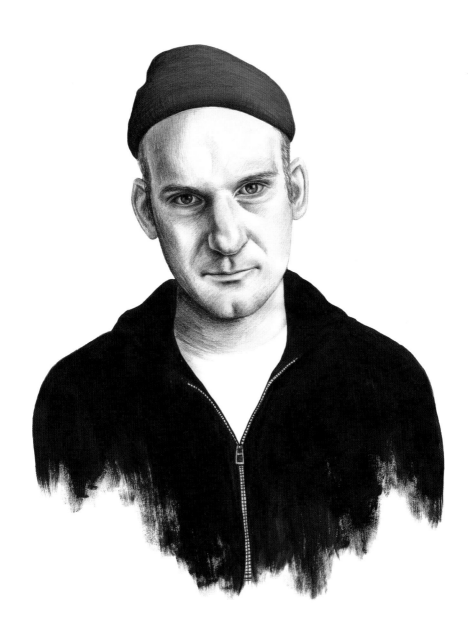

— JUDD —

APATOW

FILMMAKER

Occasionally I think of a great
dick joke, like when I have Steve Carell
try to pee with an erection, and I get very
proud of myself and feel like I am adding
something very positive to the world. I
can almost feel people forgetting their
troubles and laughing, and for a moment
I feel like there is a God or a higher
purpose and I am truly happy.
God gave me that dick joke.
It all makes sense.

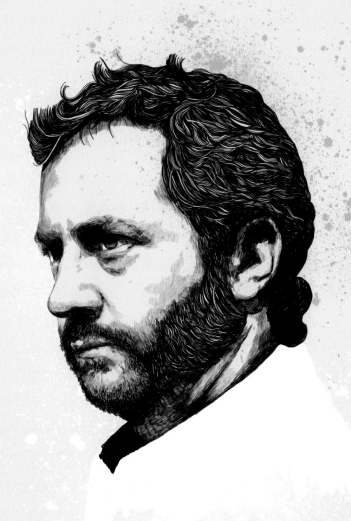

BIOS

AI WEIWEI - 140

The son of a persecuted poet, he is an avant-garde Chinese artist who specializes in challenging power and assumptions — even when imprisonment is a reality not a threat.

INTERVIEW **JOHN SUNYER**
ILLUSTRATION **MOOSE & YETI**

ALEX GIBNEY - 110

Documentary filmmaker and truth seeker who tackles mysteries ranging from corporate corruption (*Enron: The Smartest Guys in the Room*), to the inner workings of WikiLeaks (*We Steal Secrets*), to dark deeds in Afghanistan (*Taxi to the Darkside*).

INTERVIEW **D'ARCY DORAN**
ILLUSTRATION **MISS LED**

ALEX KNOST - 054

Retro-futurist surfer and Tomorrows Tulips frontman whose experimental approach to waveriding on 1970s boards and love of all things psychedelic and lo fi is reigniting corporate surfing's DIY roots.

INTERVIEW **SHELLEY JONES**
PHOTOGRAPHY **ADRIAN MORRIS**

BECK - 066

Musician whose kaleidoscopic archive skips from folk to funk and every genre in between. After ten records, he opened up his songwriting process to fans, inviting them to reinterpret songs he would never record.

INTERVIEW **GARRY MULHOLLAND**
ILLUSTRATION **KATE COPELAND**

BEN GIBBARD - 108

Singer-songwriter with a novelist's eye. As frontman of Death Cab for Cutie and The Postal Service, he rose through the indie ranks by crafting confessions and scientific observations into sleeper hits.

INTERVIEW **ADAM WOODWARD**
PHOTOGRAPHY **TOBY COULSON**

BEN HARPER - 104

Singer-songwriter and multi-instrumentalist, equally at home whether he's fronting a band (Fistful of Mercy and Relentless 7), playing intimate solo sets, or supporting environmental projects like The Surfrider Foundation.

INTERVIEW **TIM DONNELLY**
PHOTOGRAPHY **DANNY CLINCH**

BOB BURNQUIST - 044

Gravity-defying Brazilian skateboarder who once launched himself off a vert ramp into the Grand Canyon, he works tirelessly to raise eco-awareness among the skate and surf community about issues affecting our natural playground.
INTERVIEW **ZOE OKSANEN**
PHOTOGRAPHY **ADAM CRUFT**

BOOGIE - 112

Serbian street photographer whose self-initiated projects on gang culture and drugs capture the human condition in the darkest corners of society.
INTERVIEW **ROB BOFFARD**
PHOTOGRAPHY **GREG FUNNELL**

C.R. STECYK III - 120

Artist, photographer and countercultural correspondent, his "Dogtown Articles" of the 1970s are a vital part of skateboarding's canon and his contribution to the culture still manifests today as art shows and films that champion the DIY spirit.
INTERVIEW **KEVIN DUFFEL**
PHOTOGRAPHY **LOU MORA**

CAT POWER - 034

Cult singer-songwriter and downtown icon whose smoky voice channels her Southern soul roots through 1990s NYC indie to deliver heartbreaking home truths in the vein of her heroes Patti Smith and Bob Dylan.
INTERVIEW **SHELLEY JONES**
PHOTOGRAPHY **MIKE BELLEME**

CHERYL DUNN - 028

Photographer, filmmaker and champion of the underground. Her seminal documentary *Everybody Street* is a time capsule of NYC's rich history of street photography told through rare interviews with pioneers of the form.
INTERVIEW **SHELLEY JONES**
PHOTOGRAPHY **KATE COPELAND**

CHIMAMANDA NGOZI ADICHIE - 122

Her characters are like the Harmattan, the dust particles carried far and wide by November winds. Although altered by their journey, they never forget their origins. She explores the world through the eyes of the diaspora of Nigeria, Africa's most populous country, revealing new cultural connections.
INTERVIEW **ANDREA KURLAND**
PHOTOGRAPHY **JO METSON-SCOTT**

CHUCK PALAHNIUK - 094

His dark acerbic novels, such as the transgressive classic *Fight Club*, play out like a postmodern existential crisis, exploring the friction between pervasive materialism and our base desire for self-determination.
INTERVIEW **ED ANDREWS**
PHOTOGRAPHY **ROBERT YAGER**

DAVE EGGERS - 086

Author, activist and artist. A laureate of loss, who, by founding the 826 National network of tutoring centers, has moved beyond his own career to have a community impact.
INTERVIEW **D'ARCY DORAN**
PHOTOGRAPHY **ARIEL ZAMBELICH**

DAVE RASTOVICH - 134

Surfer, activist and warden of the environment, he's put his weight behind headline-grabbing campaigns in a bid to save endangered ocean dwellers on the brink of extinction, like the Maui's Dolphin.

INTERVIEW **STEVEN FROHLICH**
PHOTOGRAPHY **HILTON DAWE**

DAVID BYRNE - 082

Combining elements of punk rock, art rock, avant-garde, pop, funk, world music and Americana, he is a relentless innovator who embraces new technology as a canvas for albums, books and creative projects.

INTERVIEW **SHELLEY JONES**
ILLUSTRATION **CLAIRE MATTHEWS**

DON LETTS - 100

British-born musician and community-creator, he channeled his Jamaican roots in the 1970s to overcome racial barriers separating ska from punk, forging a new inclusive space in which civil rights could thrive.

INTERVIEW **CIAN TRAYNOR**
ILLUSTRATION **TIMBA SMITS**

DOUGLAS COUPLAND - 022

Canadian novelist, artist and cultural theorist, his books foreshadow critical shifts in culture, like the seminal *Generation X: Tales for an Accelerated Culture* which distilled the maelstrom of 1990s youth into a generation-defining turn of phrase.

INTERVIEW **D'ARCY DORAN**
PHOTOGRAPHY **GREG FUNNELL**

ED TEMPLETON - 090

Self-taught artist and skateboarder who channels the frustrated energy of his suburban roots into fine art paintings and street photography that captures Southern California at its most absurd.

INTERVIEW **MICHAEL FORDHAM**
PHOTOGRAPHY **TOBIN YELLAND**

EDDIE VEDDER - 138

As Pearl Jam frontman he helped create the template for East Coast grunge. As a surfer and eco-activist he pushes for change and was an outspoken critic of the Bush regime.

INTERVIEW **TIM DONNELLY**
PHOTOGRAPHY **DANNY CLINCH**

GEOFF MCFETRIDGE - 052

Graphic designer who distills complex narratives into simple hand-drawn lines. He cut his teeth at Girl Skateboards, art directed the Beastie Boys' magazine *Grand Royal* in the 1990s and is a regular collaborator of Spike Jonze.

INTERVIEW **ANDREA KURLAND**
PHOTOGRAPHY **ANDREW PAYNTER**

GREIL MARCUS -128

Rock writer revolutionary whose work as an author, music journalist and cultural critic in cult pulp like *Rolling Stone* and *Village Voice* placed shifts in music within a socio-political context to reveal new conclusions about the zeitgeist of the time.

INTERVIEW **SHELLEY JONES**
ILLUSTRATION **ADAM CRUFT**

HARMONY KORINE - 056

Enfant terrible whose surreal, subversive films take inspiration from his skate rat youth — as documented in the script he wrote for Larry Clark's docu-fiction *Kids* — elevating the gutter dance to indie art form.

INTERVIEW **SHELLEY JONES**
PHOTOGRAPHY **ARI MARCOPOULOS**

HENRY ROLLINS - 068

Freewheeling fireball who gave a voice to frustrated youth as frontman of iconic 1980s Californian hardcore band Black Flag and then channeled his political energy into radio, TV, and spoken word performances to share egalitarian insights from life on the road.

INTERVIEW **SHELLEY JONES**
ILLUSTRATION **TIMBA SMITS**

IAN MACKAYE - 142

Godfather of punk's DIY attitude, his seminal bands Minor Threat and Fugazi triggered straight-edge and post-hardcore. His DC record label, Dischord, remains a temple of independence, visited by punk pilgrims.

INTERVIEW **JON COEN**
ILLUSTRATION **SARAH NIEMANN**

JUDD APATOW - 144

Director, writer and all-round funny guy. Whether he's producing Lena Dunham's generation-defining *Girls* or poking fun at his own family as the auteur of *This Is 40*, heartfelt humor is Apatow's USP.

INTERVIEW **MIRANDA JULY**
ILLUSTRATION **PETER STRAIN**

JULIAN CASABLANCAS - 074

Singer-songwriter and frontman of The Strokes, he put out a solo record on his own independent imprint, Cult Records, which has become a home for idiosyncratic acts like Har Mar Superstar.

INTERVIEW **NIALL O'KEEFE**
PHOTOGRAPHY **YSANYA PEREZ**

KALLE LASN - 118

Estonia-born, Vancouver-based publisher of transgressive magazine *Adbusters*, which pioneered culture jamming with its idiosyncratic critique of consumer capitalism and became a bible of rebellion for the Occupy Movement during the 2011 financial crisis.

INTERVIEW **VINCE MEDEIROS**
ILLUSTRATION **MISS LED**

KELLY SLATER - 024

Eleven-time World Champion Surfer and the most medaled man in the water, he's dominated the professional surfing circuit since the 1990s and is still broadening the horizon of possibility in the pro waveriding game.

INTERVIEW **MICHAEL FORDHAM**
PHOTOGRAPHY **GUY MARTIN**

KIM GORDON - 060

Improvisational lynchpin of next-level noise punk band Sonic Youth who transitioned from the creative anti-capitalist ideals of 1980s NYC No Wave to become an experimental icon in art, literature, fashion and film.

INTERVIEW **STEVIE CHICK**
PHOTOGRAPHY **GREG FUNNELL**

KURT VILE - 064

Dreamy drifter musician from Philly who garnered respect in The War On Drugs but left an emotional imprint with his solo strand of heartbreaking blue-collar Americana.

INTERVIEW **CIAN TRAYNOR**
PHOTOGRAPHY **JUSTIN MAXON**

LANCE BANGS - 038

Subcultural archivist whose eye for character leads him around the backwaters of the American dream — from skate slapstick to musings on music — patiently documenting unsung heroes in authentic, sensitive films.

INTERVIEW **SHELLEY JONES**
ILLUSTRATION **KAREENA ZEREFOS**

LARRY CLARK - 076

Filmmaker and photographer known for never sugarcoating youth. Cult classics like *Kids* may show the darker side of teen life, but it hasn't stopped youth culture from endlessing referencing his intimate and sometimes brutal aesthetic.

INTERVIEW **SHELLEY JONES**
PHOTOGRAPHY **BRYAN DERBALLA**

MARK GONZALES - 070

Wizard of street skateboarding and contemporary artist, he hoisted the skate industry from an early grave in the 1990s by moving beyond the confines of the vert ramp, triggering skateboarding's explosion as a global cultural force.

INTERVIEW **ANDREA KURLAND**
PHOTOGRAPHY **WILL ROBSON-SCOTT**

MCA - 026

Badass Buddhist Beastie Boy who found anarcho-enlightenment as a civil rights activist, supporting the Tibetan Independence Movement until his untimely death in 2012.

INTERVIEW **BRUNO TORTURRA NOGUEIRA & FILIPE LUNA** PHOTOGRAPHY **MAYA HAYUK**

MIA - 136

Bhangra rap musician and cultural agitator, she inherited her radical voice from her Tamil revolutionary father to produce a hybrid sound that mashes U.S. dance with London grime and resonates like a gun in a shrine.

INTERVIEW **PHIL HEBBLETHWAITE**
PHOTOGRAPHY **SPENCER MURPHY**

MIKE D - 080

Curator of realness who paints a picture of the streets whether he's heading up the Beastie Boys, who gave 1980s Brooklyn a sound, programming events for art insitutions like LA's MoCA, or designing interiors for talk-of-the-town clubs in NYC.

INTERVIEW **BRUNO TORTURRA NOGUEIRA & FILIPE LUNA** PHOTOGRAPHY **MAYA HAYUK**

MIKE MILLS - 032

Mumblecore writer, filmmaker, music video director and graphic designer who wooed Hollywood with award-winning films like *Thumbsucker* and *Beginners*, exploring universal ideas of identity and loss in surprisingly accessible avant-garde ways.

INTERVIEW **ADAM WOODWARD**
ILLUSTRATION **OLIVER STAFFORD**

MIRANDA JULY - 072

Writer, filmmaker and performance artist. Her books and films explore our universal need to connect, and the group projects she conceives bring her own connections to life.
INTERVIEW **JUDD APATOW**
PHOTOGRAPHY **DARYL PEVETO**

MOS DEF - 116

Rapper, actor, speaker of truth. His actions hit harder than his lyrical chants, whether he's protesting against racism or the treatment of prisoners in Guantanamo Bay.
INTERVIEW **TIM DONNELLY**
PHOTOGRAPHY **ANDREW DOSUNMU**

NAS - 030

One of the greatest emcees of all time who pushed modern hip hop into new artistic realms with iconic albums like *Illmatic* — a soundtrack to 1990s Queens, New York. He lived through a dark time in music, when people died in the name of rap, but with one hand on the mic he survived to tell its tale.
INTERVIEW **SHELLEY JONES**
PHOTOGRAPHY **GREG FUNNELL**

PENNY RIMBAUD - 130

Former coalman who founded anarcho-pacifist punk band Crass. Their English country comune became a hotbed of subversive music, art and culture that's inspired radical artists like Banksy to coolhunters like Angelina Jolie.
INTERVIEW **SHELLEY JONES**
PHOTOGRAPHY **PAUL CALVER**

PHARRELL WILLIAMS - 096

Producer, songwriter, curator, and illuminati of pop culture who came of age in influential funk hip hop band N.E.R.D. He churns out pop classics and champions individual creativity via his media platform, I Am Other.
INTERVIEW **RICHARD CUNYNGHAME**
PHOTOGRAPHY **GRANT ROBINSON**

RALPH STEADMAN - 062

Artist and illustrator who gave shape to the Gonzo ramblings of Hunter S. Thompson with equally influential stream of consciousness drawings that flowed as freely as Hunter's untamed train of thought.
INTERVIEW **D'ARCY DORAN**
ILLUSTRATION **SARAH NIEMANN**

RIVERS CUOMO - 048

Weezer frontman whose shy exterior masks a formidable quick wit. Raised on an ashram, he practices Vipassana meditation and is a big fan of soccer, despite being the antithesis of a jock.
INTERVIEW **GAVIN EDWARDS**
PHOTOGRAPHY **ARIEL ZAMBELICH**

ROBERT RODRIGUEZ - 058

Genre auteur, filmmaker, writer and musician who makes his surreal visions manifest through dark stylistic action movies like cult classic *Pulp Fiction*, which he helped direct alongside friend Quentin Tarantino, and comic book crossover *Sin City*.
INTERVIEW **D'ARCY DORAN**
ILLUSTRATION **PETER STRAIN**

SHAUN TOMSON - 040

First South African World Champion who legitimated surfing as a professional sport in the 1970s, then overcame a personal tragedy by channeling his energy into empowering young people to steer their own lives.
INTERVIEW **JOE DONNELLY**
PHOTOGRAPHY **KEVIN ZACHER**

SHAUN WHITE - 036

Olympic snowboarder, pro skateboarder and the only rider to boast X Games gold medals across both disciplines, he's transcended his roots to star in Hollywood and embark on a career in music as frontman of his own band.
INTERVIEW **ZOE OKSANEN**
PHOTOGRAPHY **KEVIN ZACHER**

SHEPARD FAIREY - 092

Meteoric street artist whose Andre the Giant graphic weaved it's way into the fabric of metropolitan spaces everywhere, spurring clothing label Obey, magazine *Swindle*, gallery Subliminal Projects, and campaign art for the first black president of the United States.
INTERVIEW **JON COEN**
PHOTOGRAPHY **MUSTAFAH ABDULAZIZ**

SLAVOJ ŽIŽEK - 132

Rock star philosopher and critical theorist from Slovenia who takes on hypocrisy, cheap Hollywood Marxism, and the final crisis of capitalism in his radical books, films and public speaking.
INTERVIEW **VINCE MEDEIROS**
PHOTOGRAPHY **MUSTAFAH ABDULAZIZ**

SPIKE JONZE - 050

Skateboarding's gift to Hollywood. Director fueled by the urgency of youth and the only man brave enough to bring *Where The Wild Things Are* to life, he swept the floor at the 2014 Oscars with futuristic love letter, *Her*.
INTERVIEW **SOPHIE MONKS KAUFMANN**
PHOTOGRAPHY **KAREENA ZEREFOS**

STACY PERALTA - 098

Blond-haired hero of 1970s Venice Beach, he came of age in skateboarding crew Z-Boys, mentored Bones Brigade riders like Tony Hawk in the 1980s, then went on to produce subcultural films informed by his past.
INTERVIEW **JAY RIGGIO**
PHOTOGRAPHY **NATE BRESSTER**

SWOON - 126

Figurative street artist and community enabler who captures the stoic faces of the people she encounters — whether she's working with earthquake survivors in Haiti or victims of domestic abuse in Mexico — bringing a sense of humanity to the art establishment's walls.
INTERVIEW **ANDREA KURLAND**
PHOTOGRAPHY **GREG FUNNELL**

TALIB KWELI - 124

Rapper and activist of politically minded 1990s hip hop duo Black Star, alongside the indomitable Mos Def. His prolific output often carries a social message, tuning ears into issues like racial stereotyping and police brutality.
INTERVIEW **ED ANDREWS**
PHOTOGRAPHY **ALEX WELSH**

THOMAS CAMPBELL - 088

Filmmaker and artist who is reviving surf and skate culture's handcrafted heyday with folk-inspired art, sepia-tinted films, and an indie label, Galaxia Records, which connects the dots between waveriding and jazz.

INTERVIEW **CHLOE ROTH**

PHOTOGRAPHY **ANDREW PAYNTER**

TOMMY GUERRERO - 102

Key member of influential skate crew Bones Brigade who went on to create an improv-heavy, jazz-soaked sound, spurring albums like *Soul Food Taqueria*, which made *Rolling Stone*'s "Best Of" list.

INTERVIEW **DAVE CARNIE**

PHOTOGRAPHY **CLAUDINE GOSSETT**

TONY ALVA - 042

Dreadlocked poster boy of Californian skate crew Z-Boys who transformed skateboarding from track sport to exploratory culture, pioneering new tricks and a lifestyle that became a youth phenomenon in households all over the world.

INTERVIEW **SAMI SEPPALA**

ILLUSTRATION **OLIVER STAFFORD**

VINCENT MOON - 106

Independent filmmaker who conceived La Blogoteque's *Take Away Shows* as a backstage pass to the world's biggest bands and now wanders the planet to collaborate with unchampioned indigenous musical talent.

INTERVIEW **RUSSELL SLATER**

PHOTOGRAPHY **FRANCK FERVILLE**

WERNER HERZOG - 078

Existential storytelling astronaut who documents outsiders like cannibals, death row inmates, and grizzly bear hunters in his trippy films which are adored by curious minds and dissected at his Rogue Film School, which "does not teach anything technical."

INTERVIEW **SHELLEY JONES**

ILLUSTRATION **CLAIRE MATTHEWS**

THANK YOU

Jamie Brisick, Michael Fordham, Andrea Kurland, D'Arcy Doran, Clive Wilson, Bindi Kaufmann, Taryn Paterson, Lucinda Townend, Shelley Jones, Ed Andrews, Timba Smits, Oliver Stafford, Wendy Klerck, Dave Eggers, Douglas Coupland, Emily Haynes, Emily Dubin

And every single contributor — writer, photographer, illustrator, filmmaker, designer — who has helped make *Huck* what it is today. Cuz the thing is: you can't make these things on your own. Magazines that want to document life as it is, on the ground, and give voice to the people who are, day in day out, living life and making culture and changing the world, can only be made one way: together — editor, reader, contributor and the inspiring people they cover. Mix them all up and hopefully the end product is something that illuminates, that entertains, that inspires. It's a combo without which *Huck* magazine, and this book, wouldn't exist.

So thanks all — you know who you are!
Let's do this again sometime.

— *Vince Medeiros*
Founder, *Huck*